Junkyard Love Letters

Poetry and Photography
by
John Charles Griffin

Acknowledgements

Caroline Aiken, Edwin Atkins, Jessica Betts, Diana Blair, Tamara Colonna, Cathy Cone, Wilby Coleman, Mama Louise Hudson, Monroe Hudson, David and Judy Griffin, George and Mary Lou Griffin, Harold Griffin, Livingston Properties, Michael Pierce, Frida Raley, Carl Rausch, Joe and Jo Ann Sisson, Sarah Griffin Suttles, Alexis Vear, Sandy "Blue Sky" Wabejigig, Randy Wesson, Kirk and Kirsten West

Special Thanks

Wesleyan College Campus, Wesleyan Equestrian
Center and Wesleyan Arboretum Trail.

Derek McDaniel at McDaniel's House of Rust
 3411 Memorial Drive Waycross, GA 31503
 Junk car in front cover photograph by author

Holiday Terrace Motel U.S. Highway 1 Hilliard, Florida
 Back cover photograph

Amelia by The Sea at Fernandina Beach

Macon Museum of Arts and Sciences

John Mollica and Brandy Mohn

Katherine Walden: Proofreading

Jeff Payne: Dirt Road Tour Management

Brenda Lee Stepp: Publicity and Promo

If there ever was a time for reflection, that time is now. Poetry and photography offer the chance to enter the world of a great story teller who knows his way around words and images. It is a powerful invite. In Junkyard Love Letters, John Charles Griffin knows the terrain intimately. He is a man of the South: churches, moonshine, shotguns, charlatans and saviors, catfish and whiskey scatter his landscapes. His guidance is sure footed. He's lived the life, actually been there. Let go of the edges and dive in. You will enjoy every moment of this book.

- Bill Payne

Bill Payne is an Author, Photographer, Musician, Songwriter, Recording Artist, Grammy Nominee and Founding Member of LITTLE FEAT

www.billpaynecreative.com

Don't look down, your shoe's untied.
Photography by Gilbert Lee

Quotes / Accolades

"John Griffin's poetry is like a cement mixer doin 70 miles an hour down a twisted gravel road . . . So just strap yourself in & hold on."

-Kirk West, Author, Professional photographer at Gallery West

"John Griffin's poems are swept by leaf smoke. The steel belts of night driving carry him from regret to regret. He is the troubadour of the late afternoon phone call and these postcards mailed to his friends."

-Kevin Cantwell, Dean of Graduate Studies, Macon State University, Poet and Author *One of Those Russian Novels* (2009). Contributing Editor, *Writing on Napkins at the Sunshine Club: An anthology of Macon Poets*

"In another raconteur's ramble through south Georgia's dirt roads, John Griffin has given us nothing short of poetic moonshine from a Mason jar, in his latest collection from Snake Nation Press, *Junkyard Love Letters.*"

-Katherine Walden, Interior decorator, Freelance feature columnist

"John Charles Griffin is back again with yet another fine collection of uncommon musings in *Junkyard Love Letters.* He is fueled by an imagination born from a raising in such exotic places as Hahira, Valdosta, and other South Georgia destination stops. Griffin has drawn inspiration, partly, while bicycle pedaling along U.S. 41 and lesser trails, passing junkyards, kudzu choked telephone poles, making trips to Ace Hardware and Kroger to retrieve life's necessities."

-Paul Hornsby, Musician, Author, Muscadine Studio Owner and legendary Recording Engineer

Table of Contents

In loving memory of Lil' Mr. Murphy, Dominique, Lucy Cone, Bandit and Blitz

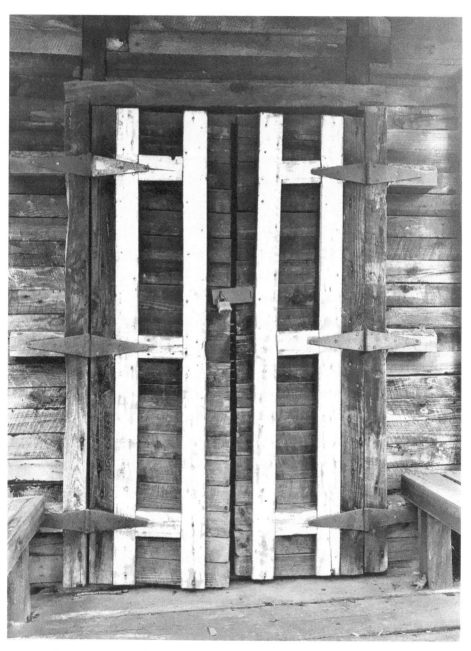

Cabin doors at the Museum of Arts and Sciences Nature Walk

1

SOUTHERN CHARM

Chasing Love

Mama drove her car down a dirt road
headed off to work in a factory
a child ran behind the wheels
chased love through pouring rain
fell down in a puddle of tears
Granny in her apron lifted him up
took him home to a shotgun house
with an old piano in the dining room
a cookie jar by the kitchen window
surrounded with crape myrtle shrubs
freshly plowed fields of Spring
a twisted oak in the yard
harboring a fox squirrel nest
crocus sacks and buckets under a shed
where snakes shed skin and birds laid eggs
home to a perfect pair of dogs, Duke and Duchess
a John Deere tractor and a gas can
an old cane grinder sitting still
near a log cabin filled with hay bales
after Henry the blindfold mule died,
remnants of a burnt barn nearby
time goes in reverse with memories
of rural free delivery and bookmobiles
Mama returned with groceries and hugs
bringing laughter and smiles to her children
where time goes in reverse with memories
chasing love that lasts forever.

Lotus biscotti

Turn back time a thousand years
run marathons in summer heat
stretch out on a yoga mat
reinvent color, forget who you are
travel far and never look back
order dessert, run off calories
let go toxins, sweat poison
feed endorphins milk and honey
eat every cracker in the box
walk on water to memory banks
into a poem that never ends
pick flowers for your mother
call your family to check the weather
absorb good energy, seek synergy
circumnavigate adversity
become the angel that you are
and love yourself forever.

Junkyard Revisited

Memories recall uniqueness above all things
oddities and eccentrics, those who were different
hometown history in junk yard love letters
childhood memories from tobacco road
whiskey bent Goat Coppage and Turkey Rodgers
local legends who drank whiskey for breakfast
Mr. Flippo who resembled Popeye's Wimpy slept
through a stray bullet that lodged in his couch
Bunk Taylor the stuttering farm worker
spoke about the threat of dig tater ships
A.T. Tyler and Uncle Harmon drank beer in the fish bait store
with Stalvey's, their owl shaped heads and pompadours
Old Lady Bridges taught school, feared by all,
ruler in hand with eyes in the back of her head
300 pound Mr. Whitelaw taught swimming lessons
in the Lions Club pool on Church Street
lightning rod salesmen pedaled their wares
deacons in the church were hauled off to jail
their moonshine stills blasted by shotguns and dynamite
Will Jones' alligator relaxed in a chicken wire cage
Turner Roundtree a successful farmer never painted his house
Trini Lopez and Little Joe brought music and rope tricks
to the high school gym on Main Street
Highway 41 was the only route to Florida
where Ches McCartney the Goat Man was a hero
 while driving his wagon of dreams drawn by rams
everybody loved Sheriff Jewell, his monopoly
on slot machines and the bug made millions
Mozell Spells by the river on the Florida line,
served fried catfish and brown bag whiskey
hosting Black Jack gambling in a back room
Mr. Chesterfield and The Marlboro Man
brought Johnny Carson to The Late Night Show
Chet Huntley and David Brinkley reported
evening news in black & white with ashtrays smoking
Fidel Castro, Nikita Khruschev and Russian Missiles

pointed at America from The Bay of Pigs
with Lloyd Fry's corner store furnace encircled
by men wearing overhauls and khakis arrived
on tractors, in pickup trucks with whitewall tires
drinking liquor, worried about Krauts and Yankees,
reports of a monkey flying in outer space - - -
Liz Taylor, Sophia Loren, Marilyn Monroe
Marlon Brando and Paul Newman
were hotter than firecrackers
on the cover of LIFE Magazine.

The Novel

Life is full of contradictions
partly fact and partially fiction
love is a novel parlance romance
talking pictures, screen test slow dance
truth seeps through emotional friction
scripts rehearsed in memories captured
moonlight mattress, all night rapture
heaven and hell of circumstance
libraries filled with tears and laughter
rhythm of hearts and souls crescendo
childhood longings lost and found
some rescued some drowned
love is a novel parlance romance
few can ever put it down.

Love is tough and tough love tougher
where hearts throb and fantasies thrive
scattered, covered and smothered
scrambled, over easy, hard or light
with paramour pretender bluffers
fishnets capture high heel scuffers
truth or consequence, words minced
latitude solitude, gravitation attitude
hunger and sweat with tidal surge
mood swings and promise rings
musical notes inspired to sing
what human nature's senses bring
love is a novel parlance romance
few can ever put it down - - -
love is a novel parlance romance
few can ever can put it down.

Crime Rhyme

I robbed memory banks,
held up trains of thought
wrote bad poetry and
side-stepped academia.

When I dropped out of sight
I made the 10 most unwanted
non-published list.

Convicted on counts of
missing soap operas
and sentenced to
99 years in poverty,
no cell can hold me
for I shall pick the locks
with pen and ink.

Hot Shot

A fly buzzed around his face
while he watched the NASCAR Race
he tried to slap it with his hands
and missed, the fly gave him a kiss
he cussed and found a swatter
swinging wild across the room
the fly lit on his bottled water
charmed by roaring engine zoom
sounding like an insect swarm
landing on the dip and chips
fly took a sip of sweet and sour
dive bombed the T.V. screen
for what seemed like an eternity
while cars ran neck and neck
at two-hundred miles an hour
with a pileup and a nasty wreck
caution flag, tire change in the pits
gone to the kitchen for a snack
knocked down by a stream of foam
collided with his myriad face
fly took a hit with hot shot
gone first to last without a trace
went down with engine failure
no win, no draw, no place
done with buzz on oval tracks
got swept up in a garbage sack
while losers on the back stretch lagged
the housefly was not as lucky
as the winner did a figure eight
swarming with the checkered flag
champagne with a beauty queen
celebrated on Victory Lane
held a million-dollar check.

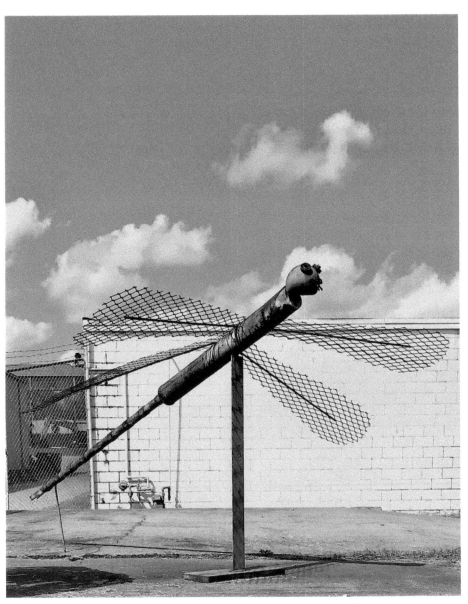

Mosquito Hawk Metal Sculpture at Schnitzer Steel Recycling - Macon, GA

Blame the weather

Blame it on the weather
gone with the clouds
laugh loud, howl at the moon
welcome lightning, celebrate thunder
watch flowers catch raindrops
in a satellite dish on a high rise
where boomerang echoes return
fallen stars embraced by gravity.

Change the channel adjust antenna
rotation with a pipe wrench
catch a passing beam of light
reset the thermostat, change the filter
keep on walking, don't stop talking
where you stand between storms
on a planet without roadmaps.

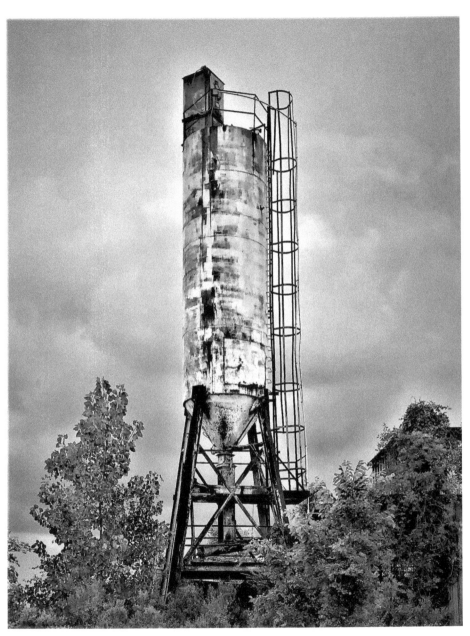

Concrete mixing tower on Macon's Lower Elm Street

Three rings

Promise rings a billion dollar
fiction fantasy power trip
time travel across light years
sword-smitten tribal battles
over stars and planets
faded metro retrograde
three rings, one for the wife,
one for the mistress - - -
the third a diamond lost
on a Gulf of Mexico beach
picked up by a metal detector geezer
on the shuffleboard circuit
golf cart driven across dunes
an elderly man named Marty with a wife
named Maudie sipping on a toddy
stashes Geritol in the glove compartment
to wake up daddy when he forgets who he is
or where the switch may be to turn on
the machinery or when to feed the poodle.
who barks with French accents
when granny plants kisses
snowbird daddy throws another biscuit
where seagulls dip and glide
reeling almost stealing
doggy treats in mid-air
ancient sand dune shorelines
shark fin Cadillac ghost rust
In a hundred billion shells.

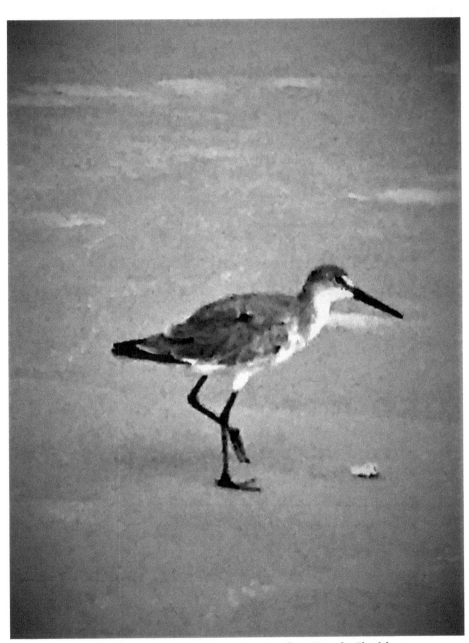

Sandpiper with a leg up on Fernandina Beach, Florida

Bread crumbs

She knew exactly when
to drop more bread crumbs
on the trail of love
to keep him hopping
like a baby chick or turtle dove
that runs behind a mother hen
she knew his every move
he read her like a book
she knew his every mood
he knew hers too
but could not stop
before he dropped
time he flew the coop
out of sight, out of mind
just in nick of time
to drink and drown
from pan-seared pink
in kitchen sink
to medium well
on fire in Hell
wasted, basted,
sautéed, fried
telephone trust
in narrative died - -
words don't matter
on worn-out wires,
where ambience dies
in churning seas
of burning sighs.

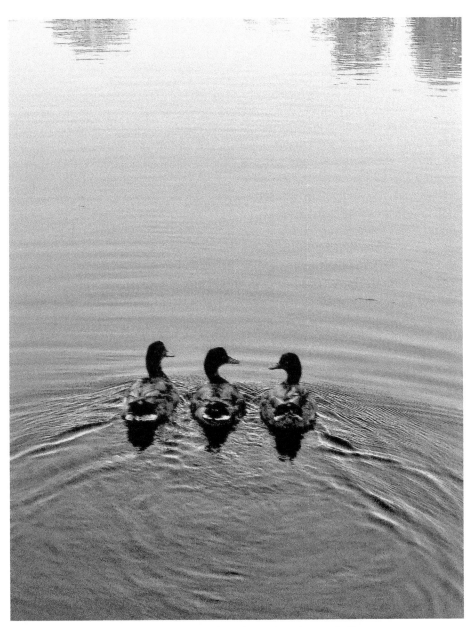

Duck Trio on Foster's Lake at Wesleyan College

Southern charm

Genetic code, bonding romance
no earthly expectations of
human needs anticipated
with old school and golden rule,
land of cotton long-forgotten
random star-crossed rendition's
fire stoked holy grail ancestry
remembering everything and nothing
refined and consumed in lonely rooms
where rock star and soldier ghosts
rest quietly near Parisian Streets
under Eiffel Tower's surreal fog
 scenes from Seine in a glass bottom boat
or Central Park Manhattan's splendor
Chaucer's Canterbury Tales in a Greyhound Bus
Where windmills remain embattled
cat's meow Egyptian mysteries
Hieroglyphic codes unspoken
unsolicited love enough
to build pyramids with Sphinx
of feline whisker's missing links
where Cleopatra finds Liz Taylor
at the altar of Hollywood haloes
Antebellum plantations erode
while Clark Gable meditates,
Vivian Leigh becomes perplexed
Big Daddy sweats and cautions Brick
about a "Cat on a Hot Tin Roof"
while a "Street Car Named Desire"
fuels fire in rhythm of Southern Rock
seduced, gone free, released, turned loose
where scenes develop, some untold
 after midnight dreams unfold.

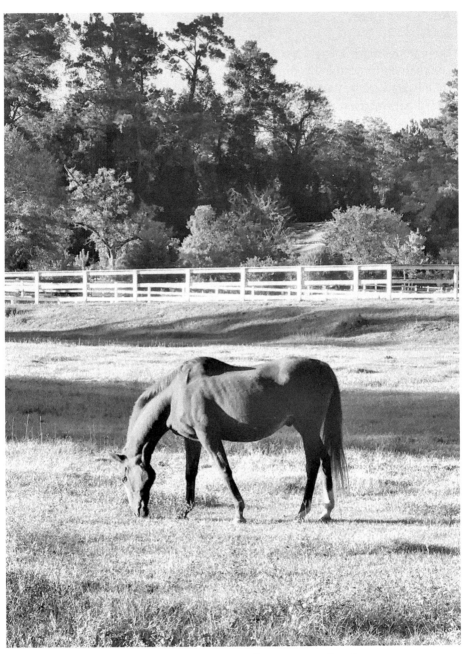

Horse grazing at Wesleyan College Equestrian Center

Adult beverages Rated PG

He read her diaries, knew her secrets
she read his tarot, told his future
their eyes were stethoscopes
heartbeats measured by metronomes
dance steps, tango, samba, rhumba
barefoot jitterbug on a Persian rug
full moon stars bloomed
no worry no hurry, no scurry
cashing in with credit cards
cross country marathon
detour at the liquor store
stopped for gas at Texaco
rented room on motel row
hot tub magic in a bottle
drank a shot, forgave forgot
dropped drawers on the floor
had sex with ex in Mexico
border crossing shotgun seat
pillow talk on checkered sheets.

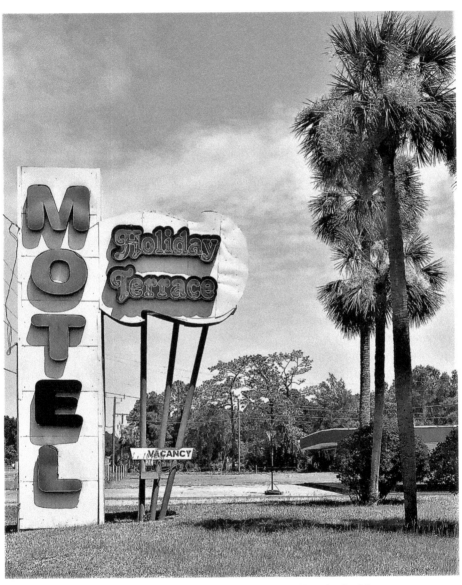

Holiday Terrace Motel Highway 1 Hilliard, Florida

Ashes to ashes

I've been resting up for a funeral
thinking about mortality and
miles down memory lane
journeys towards after life
time travel on gravel
looking for a matching suit,
clean socks and shiny shoes
in a balancing act with gravity,
prescriptions and remedies
home cooking replaced by fast food
party lines replaced by smart phones
calling to offer condolences
Cliff notes flown from cyberspace
clicked and dragged from satellites
road maps surpassed by GPS
hearses followed by promenades
enroute to memorial services
sacred celebrations of lives expired
prisoners of pain set free
honored with flowers and slide shows
gospel singers and church choirs
holy scriptures and eulogies
caskets replaced by ashes in urns
some dropped in rivers and lakes
burnt offerings returned to water
suspension bridges cross yesterday
where souls arrive and drift away.

.

Sleep Apnea

Children of wisdom find
sleep intermittent in latter days
awakening from reel-to-reel dreams,
anticipation in fast-forward
sound, sight, smell, touch and taste
insomnia calling for coffee, whiskey
or sex in early morning hours
with food for thought devoured,
souls damaged, awakened by ghosts
of solitude reaching for umbilical cords
cut loose at birth, detached
breathless, scarred and injured
beyond contentment where
pleasure plays see-saw with pain
counting seconds, minutes, days, years
stress disappears and reappears
in bedroom brain storms
where deep sleep resolves, repairs
issues face to face with demons
standing their ground firmly
unrelenting at the door to Hell
driving thru static traffic jams
reaching for light and salvation
sailing across uncharted waters
hands reach for someone, somewhere,
something to love and be loved by
where eternal holy grail discovers
happiness and heavenly bliss
while closing in on the exit ramp.

Medium Rare

She was a rare medium
who ordered her entree'
medium rare.

She was crazy pretty
and he was pretty crazy.

She wanted the main course,
side salad with pickles
he wanted dessert
with an after-dinner drink.

He often showed up early
she was usually late
held together and torn apart
by hands of fate.

He showed most of his cards
while she concealed
her secret hand
behind a smile
she was queen
of broken hearts
he was joker
gone wild.

Things fell apart
when they hit
a brick wall,
she fell down
he left town
end of story
that was all.

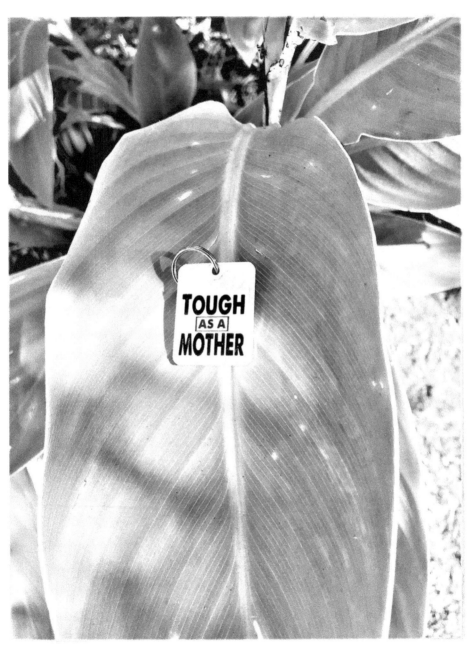

Key Ring on Plant Leaf at Wesleyan Landing

Lawn mower whisperer

He pulled the cord a hundred times
on a lawn mower made in Mexico
until his weary back got bowed
arm and bones stretched thin
sweat rolling off his chin - - -
checked oil while temper flared
pulled the air filter loose
soaked and cleaned it
with choke reset, sparks unseen,
heartbroken, inspired to cuss
madder than hell with no ignition
Hercules crashed on rocks
with muscles in remission . . .
titanium chain broke on bike
weed eater and leaf blower
followed suit, went on strike
threatened a machinery riot
while blood blisters bled
and oil leaked black
in an overgrown yard
on tall green grass.

Dive bomber

Night owl Kamakazi
chased by smoke rings
travels dark alleys
in honky-tonk dreams
heartbreak leftover
stale-bread romance
nightmare sleep walk
salt-dried teardrops
dim-lit coffee house
neon under freon
aggression surrenders
lipstick and cigarettes
drink & drown, lost & found
crawl out woodwork
bedroom baby boom
no-lead breast fed
cry over spilt milk
love note word play
pushover hangover
bar brands pay hell
dark in a moon dance
old haunts, ghosts past
oysters on a half-shell.

White tornado

Tornado take me home to Jesus
hands on a Bible in a double wide house
eye of the storm quiet as a mouse
hail yes, no snow, trees down,
 dogs on the porch, chickens on the fence.
 God spinning yarn took the cattle barn
 Millie went to heaven, Donnie went to Hell
 tried to save the whiskey still
 after dark at Lucky's Trailer Park
 string of pearls caught in a cyclone
 turning on a roulette wheel
 scratch and dent sale
 at the used car lot.

2

SPIRITUAL ARITHMETIC

Checks in the mail

My soul has been tried
my bread has gone stale
where boats take on water
no bucket to bail,
not even a pail. . .
with plans ever-changing
while standing on edge
and leaning on rails
when red flags fly high
beneath blue skies
in a world of confusion
seeking balance on scales
where hope is eternal
with checks in the mail.

Guilt Trip

You're on a guilt trip vacation
With a free travel package
no ticket or passport needed
you won't need to pass go
or collect two-hundred dollars
all you have to do
is live in the past
carry old baggage
suitcases full of garbage
a broken champagne bottle
you threw against the wall
arguments with a relative,
employer, spouse or lover
remembering the motor that blew up
when you forgot to change the oil
the night you got drunk
threw up a gourmet dinner
in a four- star restaurant
a forged note you gave the teacher
after a week of skipping school
the dope you got caught with
that you said belonged to someone else
the time you broke your hand
punching a hole in the wall
the times you told the world
to go straight to hell
the show of a middle finger,
cars you ran off the road
stop signs and red lights run
the woods that caught fire
when you dropped a cigarette
and the unpaid gambling debts
so now that this guilt trip is over
you will survive the flames
everything will be okay
now that you've landed
back in jail again.

Juvenile delinquents

Manual typewriter keyboards
pecked stories between margins
wrote love letters, business deals
orders for car wax and spinning wheels
job-search resume's and fan letters
contracts for real estate purchases
negotiations over land and cash
lightning rods and record albums
shoes, socks, gloves, coats
 jewels and license renewals - - -
like old pianos played in concert halls
measured by words per minute
wild boys sentenced to study hall
shiny apples on teacher's desk
between smokes with shirt tails out,
 juvenile delinquents reprimanded
while Tom Jones sang "What's New Pussycat"
on transistor radios in coat pockets,
Agent 007's car on a movie screen
when farm boys in flannel shirts
driving John Deere tractors to class
begged forgiveness in a principal's office
sex driven school of hard knocks
testosterone and peach fuzz sideburns
football cleats, rabbit-foot keychains
Saturday night at the Drive-In
coitus interruptus asking Jesus
for mercy in a motel room,
carnal pleasures on a hot seat
back in church on Sunday.

Tiger Woods

His caddie cried on television
while bullfrogs croaked
in a pond by a par three green
birds chirping, flowers blooming
celebration of spring for the affluent
at Augusta National Golf Course
grass immaculately cultivated
creeks covered by stone bridges
while 9200 miles away in Thailand
peasants pull carts to market
and children labor in sweat shops,
Tiger transcended scandal
fried chicken white boy jokes
and ridicule in America
putted for par on 18
to reclaim the green jacket
hugged his refugee mom
embraced his 11 year old son
enroute to the clubhouse
thumbs up, smiling, emotional,
oriental, black and proud.

Gilgamesh

The Epic of Gilgamesh repeats itself
Mesopotamia fallen under siege
lands of milk and honey
shaded by sagging palms
where hawks and doves roost
Sumerians waved olive branches
warriors chopped heads with swords
Princess of Babylon danced
around a golden calf - - -
marsh tribes sailed houses
serving grapes of wrath,
reed huts float downstream
casting nets from porches,
war lore chiseled in clay - - -
Sumerian, Hurrian, Hittite
Iconic cuneiform wedges
discovered in caves.
fast forward 3,500 years
aircraft carriers launch
laser-guided missiles to
flush out insurgents in schoolyards,
adversaries to Christian soldiers
between oil wells and hotels
where ancient villages burn
tide turns from blue to red
flying drones bomb caravans
women and children flee
from Tigris and Euphrates
wading across mine fields
calling the name of god
quoting scriptures torn in spirit
pursued by ghosts and demons
shouting the name of Jesus
Buddha, Vishnu, Mohammed
In chapels, shrines and mosques
Where hired guns in Land Rovers
dig up artifacts, oil and bones
seek Holy Grail with loaded guns
from Nineveh to Kandahar.

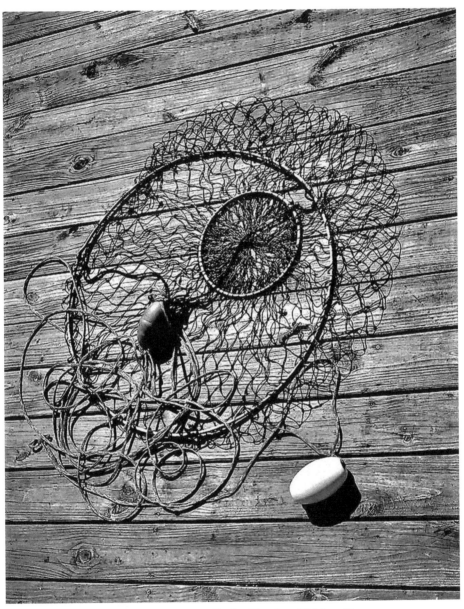

Basket Net on Amelia by The Sea Fishing Pier

Physics

Laws of physics become distorted
for a blind man making up a bed
with a hangover . . .
sheets have minds of their own
between top end and low end
pillowcases argumentative
preparing for bed and breakfast
resisting arrest
in protest of head rest
more or less a test
of kinetic organization
covered by a blanket
auditioning for a position
relief for lumbago or
potential Kama Sutra
where roosters crow at dawn
in barns by no-tell hotels
while passengers riding by
on busy streets count sheep
where Little Bo Peep
hides under a dream
beneath clean sheets.

Astrophysics

Friend and family retrograde
love hides out in cold dark caves
Jupiter's shadow crosses the equator
Seven sisters Pleiades battle Hades
palm readers battle astrologers
Taurus encounters Leo
Aries runs past Scorpio
Libra fights Cancer
Gemini holds Virgo
Sagittarius chases Capricorn
Aquarius waters oceans
Pisces swims upstream
thunder calls your name
blood pressure migraine
more than meets the eye
wet, untamed, jokers wild
where lightning bolts fly
the earth calls the moon
seeking tidal waves, tsunamis
to wash away shoreline origami.

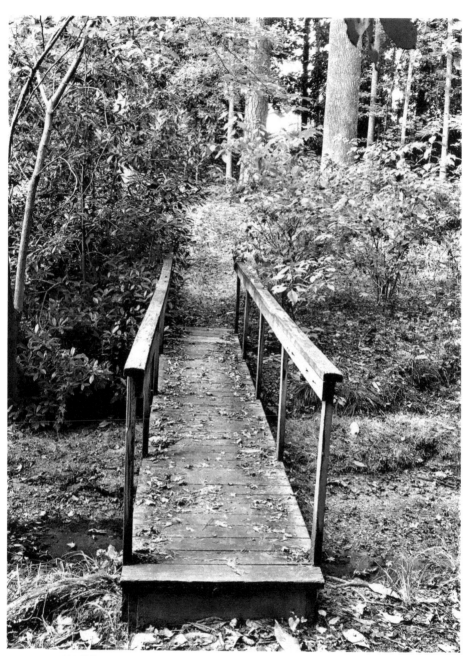

Walking Bridge over Bobcat Creek at Wesleyan Arboretum

Nirvana mirage

Rain forest contamination
where lonesome bones ache
for approval and affection
Routine lifestyles frighten
body language fades into war paint
descended from cavern walls
seduction overwhelms wisdom
territorial parts unknown
gold diggers versus chiggers
forbidden fruit on low branches
prime time tabloids bloom tulips
piranha on the Amazon
crocodile shorelines
primal urge pleasure screams
where Mercury fades
in retrograde.

The benchmark

The hypotenuse of a rhombus
remains retrograde in isosceles,
triangular in calculus,
humble pie baked
and put on simmer,
wine bottles emptied by drifters
on a concrete park bench
along the pedestrian trail
beneath a six-lane overpass
where dogs walk, sniff stumps
and trees marking territory
with salt of the turning earth
while cars and semi-trucks
go 90 to nothing on I-16 above,
past orange cones and cranes
towards Nashville, Elkhart, St. Augustine,
Key West and parts unknown.

Paris 1978

Memories of Paris, France
after latte' and liqueurs
on a boulevard sidewalk
riding past Moulin Rouge
not quite, almost drunk
to St-Michel on the Metro Line
climbing spiral staircases
of Cathedral de Notre Dame
before a Frank Zappa concert
at The Hippodrome Arena
in 1978 leaning through a portal
looking face to face, eye to eye
with hunch-back Quasimodo
protagonist monster,
hero of love after death
overlooking cityscapes.

Sinners

Sinners have no fear of darkness
in a world of jaded dreams
reality television islands
trees green sand clean
where everyone is beautiful
rehearsing their script
all claim innocence
when proven guilty
fortune cookies buy
whiskey-bent hangovers
dancing libido run loose
in popularity contests
Christian versus lion
Hindu versus Crocodile
churches rise and fall
snake bitten Garden of Eden
whiskey-stained bible study
testimony for alimony
lost and found souls
nipple slip guilt trip
sinning is winning
immersed in Holy Water
umbilical cord unplugged
overlapping memories
time weathered faces
inventory their spaces
cut losses seek gains
kneel and pray for rain
healing power miracles
new phones new bones
new leases on life
born again before all
hell breaks loose.

Life Savers

Life savers in flavors
orange cherry grape lime
shared by a friend
who made this world
a more beautiful place
in troubled times
prepared for eternity
the essence of class
in a hospital room
gracious and thankful
still counting blessings
on an adjustable bed
time running away for a soul
proof positive on dark days
accepting the hand of cards
for what is on the table
prepared to fly with angels
leaving songs behind
recorded compositions
beautiful music to
accompany spoken word
brother of boundless kindness
taking friendship to infinity
guitar strings attached
to precious memories
the rhythm of thunder
to accompany prayers in silence
lightning and falling stars
celebrate from the heavens
fireworks show of honor
bringing rhythm and rain
leaving behind ashes
of love and inspiration
feeding the earth
with joyful songs.

Broken eggs

Tectonic plates are cracked.
the liberty bell is cracked
soup is good with crackers
mountain climbers fall through cracks
some rescued with bones cracked
others never seen again tracked
slipped thru cosmic egg cracks
while miners dig miles in black
with crackling bread in paper sacks
street music horn blows in snow
Manhattan saxophones moan
rhythm, high note lips cracked
an artist cracks open cans of paint
to sounds of jazz cracker jacks
playing for free just to be
while a crackhead goes mad
with brain fried mind on streets
imaginations roam like brushes
on a snare drum or a canvas
java time coffee cup cracked
tossed turned nerves wracked
some in low lumbago bad back
rich mansions poor shack cracks
rose bowl football fibula crack
comedy show cracked-up
Mack truck gets hijacked
crime crack down declared
sailing across iceberg cracks
blessed are the meek, weak, deaf
and dumb both walking and lame
the senile mild, the wild and tame.

Alligator

Read from a hunting lodge dinner recipe
fried sidewinder diamondback, gator tail,
sliced tomatoes and sweet potatoes
where snakes in the grass
slither from the past
city boys with shiny toys
camo suits and wading boots
drink shots from sculpted glass
battered frog legs on a plastic plate
whiskey in brown paper sacks
under bible belt cypress groves
pulpwood truckers load trailers
tying chains around heavy logs
a chorus of crickets make music
serenade deer stand towers
an osprey spears a bluegill
while egrets dive for crawfish
during early morning hours,
ancient armor-plated reptile,
an old alligator rolls off
a hollow log in surreal
ethereal evening fog
where dry swamps smoke
and old growth burns.

Green Acres

Talk about claims to fame
cyber-optic trivia games
the lame the walking
the quiet and the loud
scholars and flunkies
recovering junkies
wading birds, terns and gulls
beachcombers, socialites, loners
parakeets and spoken words
real deals on dotted lines
roulette spinning wheels
movie stars and fast cars,
metal wrapped in kudzu,
jet planes and fancy boats
canceled flights to paradise
luxury ships in scrap yards
politicians sing pandemic blues
medical marijuana in the news
waiting rooms for weary bones
watching Green Acres
on a portable phone.

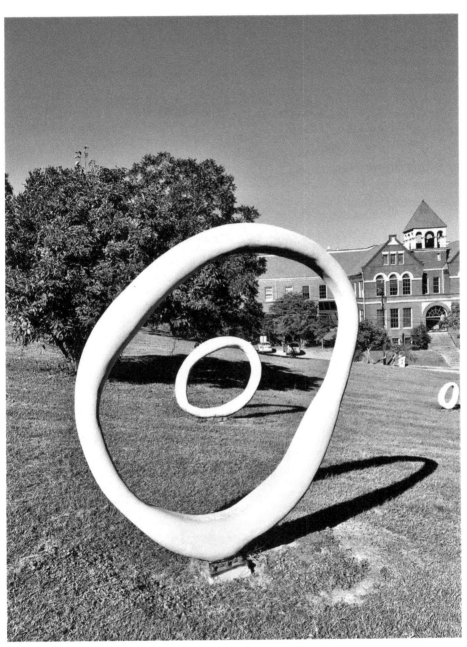

The O's on Coleman Hill

Backpack heart attack

Backpack heart attack
he said feather bed
she said no lead
snake bite wood shed
love comes hate goes
topsy-turvy tiptoes
trying on the latest style
new math arithmetic
politics & dirty tricks
latest scandal headlines
scary movie end times
Jesus on the raisin toast
Talk about the holy ghost
frowning faces stolen smiles
camel rather walk a mile
China knocking on the door
standing on the killing floor
rifles in the schoolyard
throats cut, deep scars
sleep loss dental floss
tooth paste basket case
picking up a window scraper
running out of toilet paper.

Graph Chart

Slide rules stretch
height and weight
like wild cats in
concrete jungles
beyond periodic tables
in mathematical disarray
clawing at cityscapes
statistics push their limits
over yoga mat workouts
on roller coaster curves
measured by the pound
graph charts promise
fortune teller light year
satisfaction at tunnels end
red, blue, green and purple
love potion bottles break
sharp pencils drive numbers
burning on a treadmill
sweat equity realized
put on hold
in hands
of fate.

Here Kitty

Consideration of feline adoption
awaiting arrival of an orphan
rescued from a rock & roll house
left behind by angels of mercy
moved by an angel of love
delayed by hailstorm warnings
riding in a six cylinder
BMW backseat cat box
southbound on interstate 75
frightened, longing for affection
Himalayan antenna whisker vibes
gone 100 miles to a new lease on life
running from a concrete jungle
at 73 miles per hour.

Here kitty have a treat
with a seat on the couch
eat, drink, prowl and takeover
so now you'll be just fine ...
it's okay to cry, whine or chase
a mouse around the house.

So welcome home my feline friend
storms in spring have come and gone
now it's time again to run and play
where all is calm, you're here to stay.

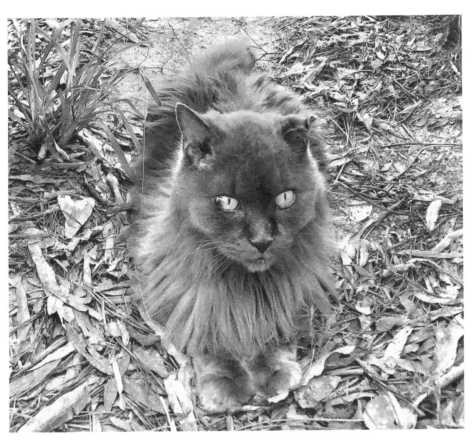

Jungle Cat

Claw marks

History of trust is nowhere
discussed in public applications
except on dollar bills or buffalo nickels
or quoted on statues, contracts
and legal documents referring to God,
seduction with creature comforts
boundaries, promises and property lines
anticipating gifts from Santa Claus,
tooth fairies and easter bunnies,
taught to rebel against truth
colored boiled eggs with prizes
placed beneath rocks and shrubs
where snakes crawl in grass and
fire ants sting, beauty of childhood's
recovery from bites and bruises,
personal growth experiences
on roads to ambition's rewards
where adolescence leaves behind
childhood scavenger hunts,
talking rabbits, singing chipmunks
and red-nosed reindeer pulling a sled
replaced by camouflage, love potions,
guns, knives and automobiles,
sex drives, business deals, profit wheel
matrimony, pony-ridden alimony
where some cats have nine lives
biological alarm clocks ring
leaving claw-marks on scratch posts
jumping out of windows.

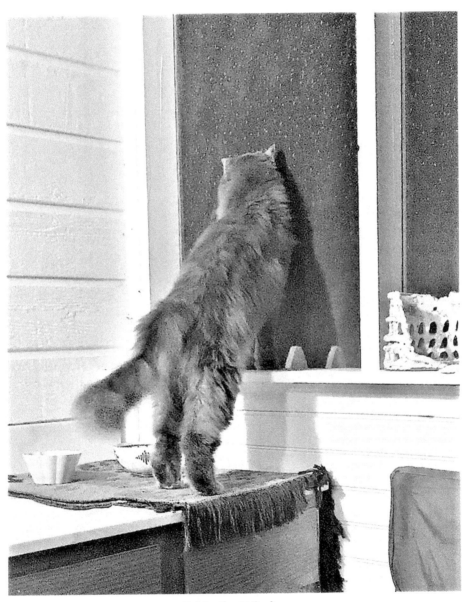

Cat in the Window

Fame and fortune

The Ivory Coast contingency offered
millions in an e-mail attachment
to claim the wealthy estate of
deceased Prince Rasheed Ali Baba
round trip tickets to Dimbroko
Kru and Baoule' language classes
a djembe drum serenade
palm fronds and shake dancers
a golden crown with diamonds
silk and coffee plantations
accommodations in a palace
overlooking a spring fed lake
protected by royal guards
while their benevolence did not
go unnoticed, their kindness
was gracefully declined
until then, maybe next time.

Everglades

Just when you thought
your life was on the right track
somebody stabbed you in the back
with a rusty knife.

Just when you thought
you'd landed on truth
somebody you loved
stole your brand-new suit

Just when you thought
you had it made in the shade
somebody dropped your body
in the everglades

Just when you found
yourself a place in the sun
somebody held your head
against a loaded gun.

Just when you thought
you were having fun
somebody came along
and punched you in the gut

Love and betrayal
found you on the edge
losing the past, everything
looking over the ledge.

Nosexatol Rx

She robbed Peter
to pay Paul
got strung out
on Nosexatol.

She used to be
the belle of the ball
where men bowed down
when she did call.

Turned frigid
got the chills
Just for a thrill
took another pill
Nosexatol

She no longer had
wants and needs
not necessary
to do the deed ...
Nosexatol.

No more hard times
no more petting
no more need for
letting and getting ...
Nosexital.

No more teasing
Begging or pleading
no more wanting
no more needing
with the miracle drug
Nosexatol.

Miracle drug
Nosexatol
miracle cure
Nosexatol
okay y'all
that's all.

Kick Ass

You're on a one-way street
down a dead-end road
where this poem can
kick your poems ass

If you don't have rhyme
or good vibes in time
then go to hell away
because this poem can
kick your poems ass

No need lock jaw
find a new faux paw
no need for angry lips
step off the battleship

Spilt milk chill pill
thank you for the guilt trip
fly low drive slow
turn up the stereo

Better cheap hotel than hell
don't mess with my mojo
because this poem can
kick your poem's ass.

Neap tide

Life flashes by in a moving van
jump starts past tense to future
telephone anxiety in traffic jams
conversation sparks are strained
diminished in blur of stop lights
fast lane blood pressure on hold
wheels turn before the bus leaves
no time for sleep or conversation
not even a quickie or a one-night stand
no time for dinner, not even an appetizer
bottle of wine, entre' or dessert
relocation no time for hesitation
while needing a drink, dehydrated
like a soybean patch in a dust storm
old furniture dropped in a dumpster
roads to the future under construction
migrant laborers wearing orange vests
hold MEN WORKING signs dodging traffic
like matadors in Tijuana or Pamplona
U Haul trailer rides flat tires in a junk yard
fueled by energy bars from a cookie jar
riding on a roller coaster in reverse
free to be gone free to move on
under glimmering light over neap tides
body surfing slowly to the next wave.

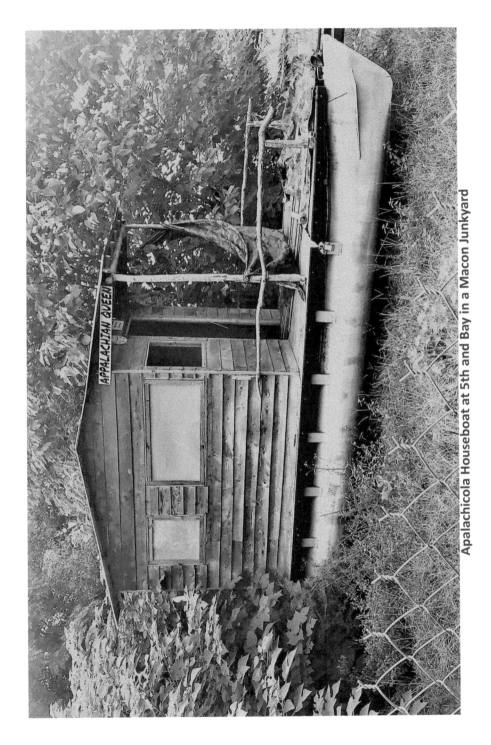

Apalachicola Houseboat at 5th and Bay in a Macon Junkyard

Uncle Arthur

He was a Veteran Soldier
standing tall, no small talker
when arthritis kicked his ass
broke his cane and stole his walker
on rainy days with aches and pain
when weather jumped their bones
lumbago could not do the tango
or sing with Beatles dance with Stones
carpel tunnel, tennis elbow, Achilles heel
hands that delivered TKO's no longer feel
on cloudy days where knee-joints pay
and hips can't do the hula
holding rails in steep stairwells
calling on Jesus or Buddha
for spiritual cures hoodoo-voodoo
whiskey risky way past sixty
waiting on drug store miracle cures
stuck on a reef under rolling tides
on a slow boat from China.

3

PANDEMONIUM

Radio Free

Words wage war with understanding
giving way to rhythm outside the box
in coffee shops, wine and cheese bars
conversations scrap with intellect
spelling bee hive language rants
speak jive running from academia
the homeless talk to chirping birds
saltine nourishment in a sardine can
Lucky Strike smoke screen
bootleg whiskey, spiritual grace
lottery ticket redeemed
hoochie mama prom queen tattoos
fading pictures of a gone world
looking up at helicopters
picking up wounded souls
on the road to salvation.

The last poem

Doves turn into hawks take shots
power tripping on killer instinct
fabrication versus creativity
metal versus flesh
where feathers fly
no mercy for the meek
kangaroo court-tried
truth kidnapped hog-tied
padlocked in a pirate trunk
flags dragged through mud wave blood
bridges burned engines revved
seatbelts unbuckled brakes failed
camouflage joyride outrage
by men without masks wearing
red hats on hand grenade road
Russian collusion side-bets
coin-op money laundromat
demolition depth charge
power undermines wisdom
family and friends turn foe
in wounded bullet-ridden fear
traveled souls no longer
consumed with fire and heat
sending out olive branches
in love measured by trust
shedding tetanus rust to shine
like precious minerals.

Shootout at Covid Corral

C.V. the outlaw rode into town
said he was gonna' take us all down
when we hit him up with a snort of crown
fought the fever in a one horse town
vodka blend and a shot of bleach
turned him slipshod out of reach
with sticks of incense from '73
a cockroach bomb to set him free
locked the doors and mopped the floor
when he knocked on the window back for more
then we popped him again with lemon juice
dose of citric acid on salted wounds
he flew through the air in a leaping loop
then we washed the groceries in alcohol,
sprayed the mail with aerosol
dressed to kill in germ proof masks
with spray in hand and powder packed
told the neighbors stand six feet back
old Coby ain't welcome around these tracks
just got evicted from the county jail
with churches ringing funeral bells
gone to a rally with Mustang Sally
now C.V.'s on the road to Hell
 C.V.'s on the road to Hell.

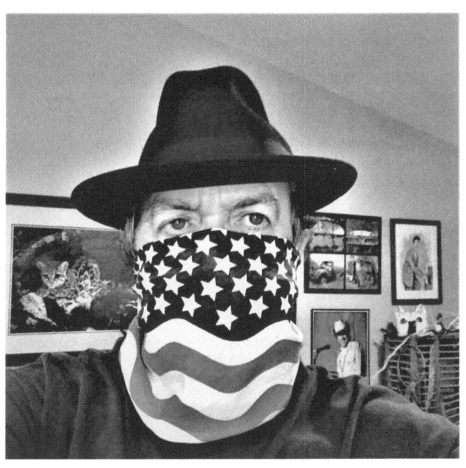

American Stars and Stripes Mask

Crazyville

Some drink whiskey, some take pills
living down yonder In Crazyville
Some of them argue with looks to kill
that's how it goes down In Crazyville.

They kick & scream, just can't sit still
living on the edge In Crazyville
midnight freight train over the hill
running on rails through Crazyville.

See how they hide when the chips are down
like a roller coaster ride on a karma wheel
where right & wrong are just another song,
that's the way of living down in Crazyville.

They're feeling no pain
loaded up on pills
on a Greyhound Bus
leavin' Crazyville.

Heard all the stories and had my fill,
gonna leave that place called Crazyville.
I just wanna relax, stay home and chill
cause I'm never going back to Crazyville.

I just wanna relax, stay home and chill,
cause I'm never going back To Crazyville.

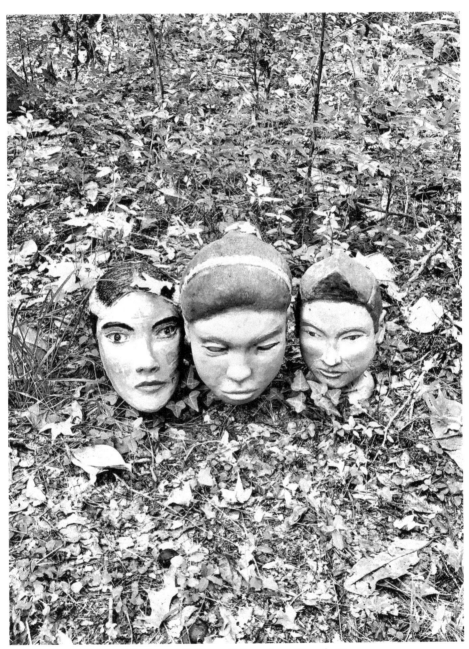

Wesleyan College Arboretum Heads Up

Bait and Tackle

You can't drain the swamp
with chemical spills
or talk show hosts
holding bottles of pills
the world is suffering
and you're still on the train
looking out the window
for somebody to blame
and this game of roulette
is too much a mess . . .
that dog won't hunt,
time to drop back and punt
so wake up Bubba, spit out the bait
you can't cover up the Klan
or Make America Great
with pearly white rallies
screaming red hat hate.

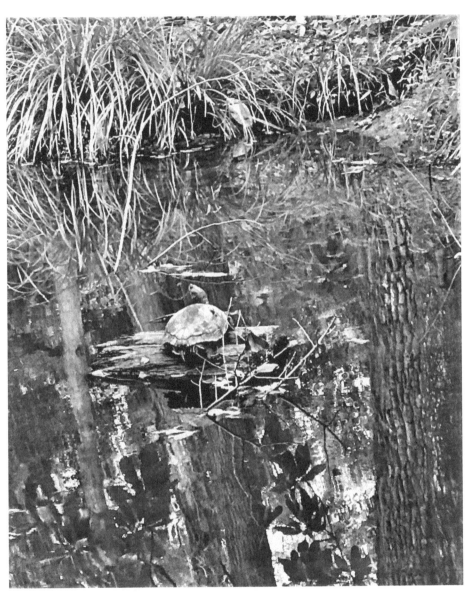

Turtle Pond - Museum of Arts and Sciences

Blowing in the wind

The king of diamonds
flew acrobatic loops in mid air
with frequent flyer miles
high altitudes, jet set lag
baggage and desire
seduction with glamour
walking on water wings
lost in space uncertain
rising up for more
no fear of flying
on a crop duster
over fertilizer trucks
seeking bang for a buck
aerobatic heart flutters
praying to god for healing
screaming lungs, aching breasts
congested out of breath
tyranny versus democracy
in a land of propaganda
betting against better angels
crash and burn in reverse
carnival ride of a lifetime
ascended over waving flags - - -
If only mother knew
she would've seen
those red flags too.

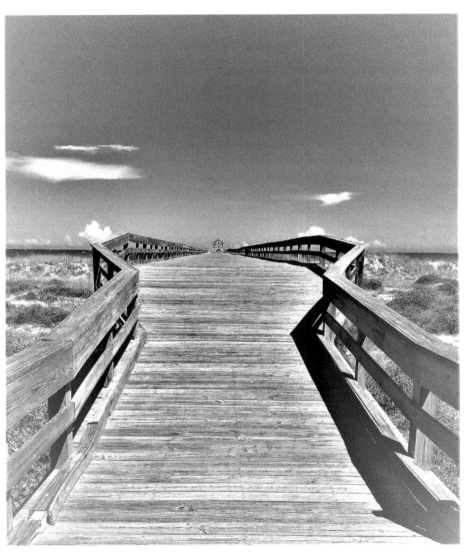

Amelia by The Sea Fishing Pier

Last supper

Evening news begins with sounds
of war drums and trumpets
musical drama for disturbed souls
reminiscent of Roman Gladiators
driving chariots across a Colosseum floor
tigers and lions chomping upon peasants
emperor and scribes sitting in box seats
Plato's Republic versus Democracy
drinking from silver cups
waving to a captive audience
sinister voices whisper in darkness
money changes partners
before the Last Supper
Jesus stands outside in the rain
fleecing a flock of sheep
washing someone's feet
waiting to be crucified.

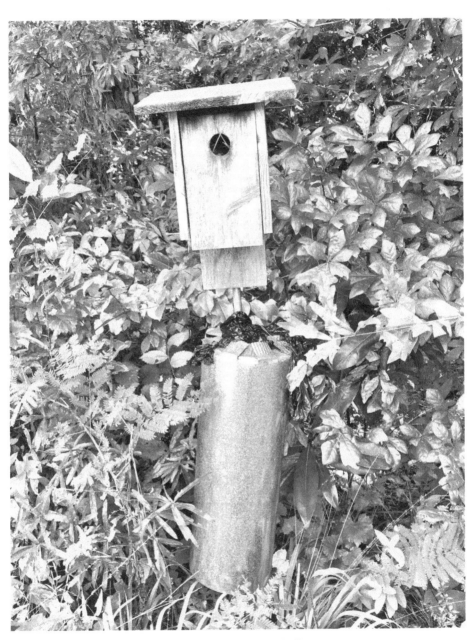

Wesleyan Arboretum Birdhouse

Meditation hour

It was meditation hour
chronologically more or less
in a world gone quarantine
by a virus from a bat cave
a secret laboratory
or the gates of hell
prime time obituaries
when earth stood still
while Chronos empowered
by lightning sharp, thunder loud
in wrath of Zeus broke loose
descended from mighty clouds
where carnival barkers summon gods
play dealer's choice jokers gone wild
russian roulette bets double or nothing
with a spin of a spell on a zodiac wheel.

Kid gloves

While pandas grunt and groan,
pandemonium sets the tone
breath trapped, lungs collapsed
 in a world gone over edges
human lives and minds perplexed
in a primetime televised hex
living color on a big screen
seeking light and comfort
 in a stream of dreams on hold,
rock of ages where love and hope
await light from above with
kid gloves holding on.

Blooming Eggplant Garden Flower

Salvation

In the heaviest year of a lifetime
crowded rooms left behind, a glance at doom
tomb of unknown soldier, children without mothers,
dogs of despair bark where sparks of hope
give reason for everything that is, the kiss
of life that quenches thirst of fates desire
driven off course on a dark horse
a quest for redemption fallen
like tree leaves dropped in autumn
pale and cold, charmed souls
on a roller coaster in a glass house
riding on bumper cars where
dark waves beckon undertow
of rising tides, we embrace dreams
where romance drives lost souls
to keep from drowning where others sink
in think tanks like fish in a barrel
we swim apart awkwardly upstream
seek islands where sunshine brings light
no resistance what Mother Nature brings
storms subside with laughter and singing
whiskey drives lips to cuss, days become night
fear shouts across an uncertain future
recycled fear in personal history
Prometheus unbound lost in space
another day another dollar gone
searching for salvation
where rocket science attempts
to ride the gravy train in vain.

Katherine Court on Mulberry Street Built 1920's

Social distance

It was the madness
not the illness
that broke the mold
in a world unfurled, lost
in permafrost gone cold
all too busy going crazy
to share the raisin toast
with those we love the most.

Author Biography photograph by Gilbert Lee
www.gilbertlee.com

"We saw pretty angels flying with devils on their trail,
from a gypsy tent revival to a lonely night in jail."
 -John Charles Griffin

John Charles Griffin is a poet and photographer. He graduated from Valdosta State University in 1984 with a Bachelor of Arts Degree in English Literature. His first book, *After the Meltdown,* was a 2016 Georgia Author of The Year Nominee for Poetry. His second book, *Dirt Road Visionary,* was published in 2018 followed by an extensive book tour to a dozen cities. Griffin serves on The Board of Trustees of The Allman Brothers Band Museum at The Big House. He is a U.S. Navy Veteran having served with Middle East Forces in the Persian Gulf. His poems have appeared in anthologies *Java Monkey Speaks, Shades and Shadows, Silver Valley Voice*, and *Velvet Crescendo*. His photographs have appeared in *Macon Magazine, Georgia Music Magazine, Gritz and Kudzoo Online*. Griffin has performed spoken word on Georgia Public Radio, at Callanwolde Arts Center, Macon's Sidney Lanier Cottage, Gallery West, Finster Fest, Poets at Pasaquan, Winterville Library and Valdosta's Turner Arts Center. Griffin spent his early years living and working on his family's farm near Hahira, Georgia.

Cover Artist

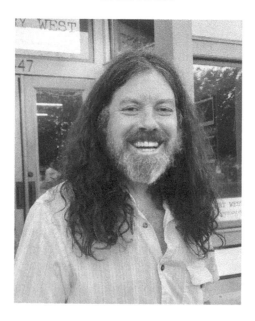

Johnny Mo

John Mollica created the cover art for this book using a photograph by the author. Mollica is a self-taught artist, lettering specialist, and concert promoter from Macon, GA. His art has appeared on album covers and merchandise for numerous rock and roll bands and his concert posters, done for bands and promoters, have become sought after collectibles. Today, Mollica focuses most of his art efforts on larger paintings and pieces that incorporate found objects, fabric and bottle caps. He is a primary force in the Middle Georgia Absurdist art movement and spends much of his time organizing and promoting events that showcase other artists and musicians in Macon and preaching the gospel from the Church of Duane Allman.

Lightning Source UK Ltd.
Milton Keynes UK
UKHW020644040123
414815UK00012B/445